My Photographer's Creative Workbook

This is my line in the sand! I am committed to becoming a more creative photographer and achieving my potential. I will overcome and stamp out all resistance!

THIS BOOK BELONGS TO

Your name here!

The companion workbook to
Achieving Your Potential As a Photographer by Harold Davis
ISBN: 978-1-138-82636-6 ©Harold Davis

BEGIN YOUR JOURNEY

You've written your name on this workbook. Wait a minute! You didn't? Well, just take a gosh darn minute and turn back a page, grab a pencil or your favorite pen, and put your Joan Hancock on the line! Okay. Good job!

Now you have your name on the front of the workbook. And you are well and truly committed to drawing your line in the sand, and to achieving your potential as a photographer.

This workbook is here to help you. But there are a couple of things you should know to get the most out of using it:

- The workbook is a companion to *Achieving Your Potential As a Photographer*, and is meant to be used in conjunction with the book. It's important that you understand that the exercises in this workbook are most fully explained and illustrated in the book itself. For each exercise, a cross-reference to the book is indicated in the workbook, like this: **For more about this exercise, please see *Achieving Your Potential* page 18.**

- The best way to use this workbook is as a kind of journal. It is *your* journal, not *my* journal, and completing the exercises helps make it personal to you. You will get out of it what you put into it.

- When using the workbook in conjunction with *Achieving Your Potential As a Photographer,* I encourage a couple of different possible workflows: You can do the exercises as you read about them in the book; or you can first read the book, and then do the exercises, referring back to the book as you need to. Mixing and matching is fine; the key thing is the *doing!*

Harold sez: I've made this workbook as much like the experience of being in one of my workshops as possible—this is a workshop in a book!

- The pages in this workbook are perforated so you can easily pull them out as needed, or you can pull them all out and put them in a binder. If you need extra copies of a workbook page to complete an exercise or to do one more than once, please feel free to photocopy the workbook pages. You can also download them in PDF format from **www.digitalfieldguide.com/achieving**.

Generally speaking, there are several kinds of exercises in the workbook, which should be approached somewhat differently. You'll find exercises that help you clarify your goals and how to plan in an organized way to achieve them. You will also find photography exercises, and exercises that are intended to enhance your creativity and conceptual abilities in a general way. In essence, the different kinds of exercises are intended to meld "left brain" and "right brain" approaches. As such, you may be more comfortable with one kind of exercise than another. But the key thing is to do them all. The more you get out of your comfort zone, the more of your potential you will achieve.

Good for you for deciding to start down the path to achieving more as a photographer. Now get out there and *do it!*

Harold Davis

Getting the Most Out of Your Companion Workbook

1
GOALS, BASELINES, AND OVERCOMING RESISTANCE

Date: _____

For more about this exercise, please see *Achieving Your Potential* page 16.

"Photography is an adventure the same as life itself."

— Harry Callahan

What are your goals as a photographer?

Where are you now as a photographer?

What do you need to do to get from where you are now to achieve your goals as a photographer?

What is stopping you from achieving your goals as a photographer?

How can you overcome the resistance that is stopping you from achieving your goals as a photographer?

Date:_____

For more about this exercise, please see *Achieving Your Potential* page 16.

THIS EXERCISE REPRESENTS AN initial process to try to pinpoint where you are now in relationship to where you would like to be, and how you can conceptualize getting there.

The point of the process is in large part repetition; in other words, you should expect to repeat this exercise on a fairly regular basis, and in particular, when you feel you have made substantial progress. It's an exercise borrowed from the business world and as such is intended to be applied to both visual (aesthetic) and practical (pragmatic) aspects of photography.

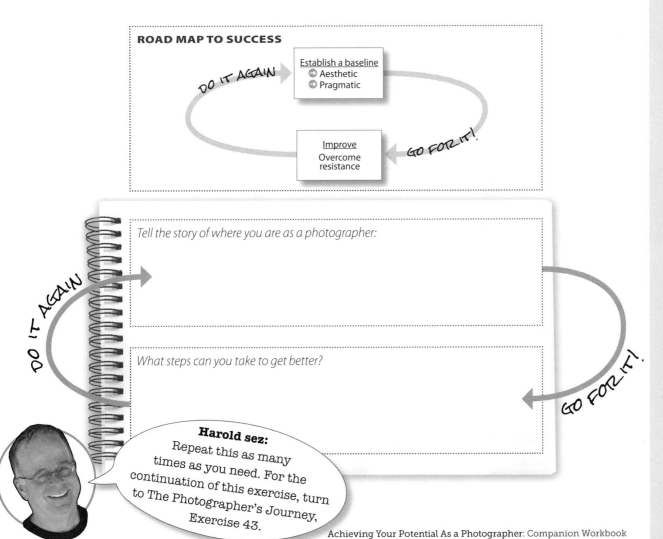

ROAD MAP TO SUCCESS

DO IT AGAIN

Establish a baseline
➡ Aesthetic
➡ Pragmatic

Improve
Overcome resistance

GO FOR IT!

DO IT AGAIN

Tell the story of where you are as a photographer:

What steps can you take to get better?

GO FOR IT!

Harold sez:
Repeat this as many times as you need. For the continuation of this exercise, turn to The Photographer's Journey, Exercise 43.

THERE ARE ONLY TWO MISTAKES ONE CAN MAKE ALONG THE ROAD TO TRUTH; NOT GOING ALL THE WAY, AND NOT STARTING

THE STEPS TO EVALUATING YOUR OWN WORK

Date: _____

For more about this exercise, please see
Achieving Your Potential **pages 20–23.**

EVALUATING YOUR OWN WORK is an important component of establishing a baseline. If you don't know how good what you have done is, how can you figure out how best to improve? The problem is that objectively evaluating one's own work can be extremely difficult even with the best will in the world. One technique that helps is disassociation, which means to try to view your work objectively rather than with the emotions you used when you made the images. Once you are disassociated as possible, you can extend your evaluation over a number of formal domains as shown in the checklist below.

The point of the exercise is to learn to establish baselines so that you can use your baseline to see how you improve following the process shown in Exercise 1.

Choose a body of work and call it:

Do each exercise and check them off when finished:

☐ Disassociating (see Exercise 4)

☐ Formal Photographic Evaluation (see Exercise 5)

☐ Emotional, Intuitive, and Narrative Response (see Exercise 6)

☐ Presentational Context (see Exercise 7)

Initial here when you have completed all the steps.

Establish a baseline. Enter a description of your baseline for your body of work here:

"THE POTENTIAL FOR GREATNESS LIVES WITHIN EACH OF US."

— WILMA RUDOLPH

EVALUATION STEPS

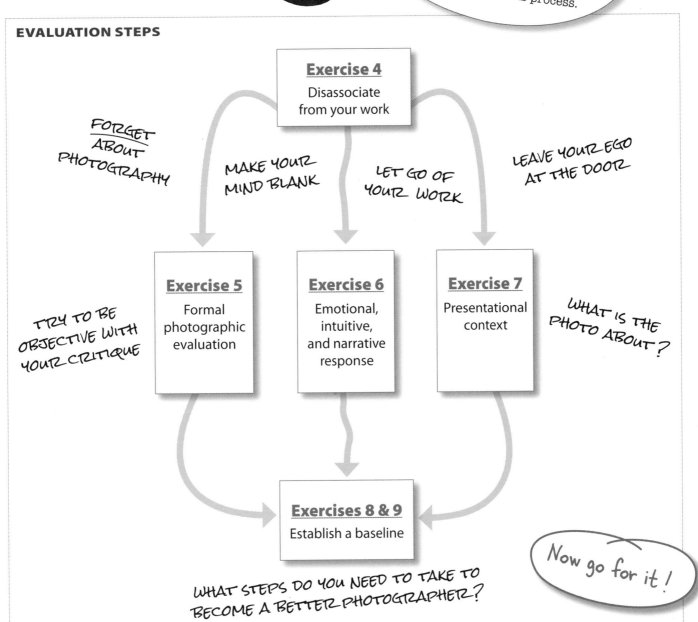

Exercise 4
Disassociate from your work

FORGET ABOUT PHOTOGRAPHY

MAKE YOUR MIND BLANK

LET GO OF YOUR WORK

LEAVE YOUR EGO AT THE DOOR

Exercise 5
Formal photographic evaluation

Exercise 6
Emotional, intuitive, and narrative response

Exercise 7
Presentational context

TRY TO BE OBJECTIVE WITH YOUR CRITIQUE

WHAT IS THE PHOTO ABOUT?

Exercises 8 & 9
Establish a baseline

WHAT STEPS DO YOU NEED TO TAKE TO BECOME A BETTER PHOTOGRAPHER?

Now go for it!

4

DISASSOCIATING

Date: _____

For more about this exercise, please see *Achieving Your Potential* page 24.

THE GOAL OF THIS exercise is to forget about photography. And in particular, your photography. This is about the only place in any of my books or workshops where I will ask you to forget about photography, but it's important that you learn how to do this.

But wait! This is a book about photography! How come you want me to forget about it? The answer is that it is almost impossible to give yourself enough distance from your own photography to evaluate it objectively and establish a baseline without learning to make your mind a blank when it comes to photography. Essentially, this involves practicing meditation, and different people like to meditate in different ways. Here are some meditation techniques that have helped other folks clear their minds:

- Listening to calm, patterned music such as Gregorian chant
- Going for a walk
- Attending a worship service or formal meditation session
- Listening to the wind and weather
- Taking a warm bath or hot tub soak with candlelight

What has helped you most meditate and clear your mind about thoughts about photography?

> "MEDITATION FOR ME IS STARING UP AT MY IMAGINARY CEILING FAN WONDERING WHAT I AM DOING WITH MY LIFE."
>
> — ERICA RHODES

Leave my ego at the door.

Someone says my photos are great or awful—I don't care anymore.

I can look at what I've done and see what is there without making a judgment.

Put my hopes, dreams, and fears about my photography away for now.

FORMAL PHOTOGRAPHIC EVALUATION

Date: _____

For more about this exercise, please see *Achieving Your Potential* page 24.

THE IDEA BEHIND THIS exercise is to evaluate your work using strictly photographic terms of reference. You want to be able to disassociate from your work as you perform this evaluation to be as objective as possible. Bear in mind that there are many formal characteristics of any photograph, and you may need to add your own categories to the list below. You can use this exercise on a per image basis, and you can also apply it to a group or sequence of work.

Is the photo in focus, or is lack of focus used appropriately?
☐ Yes ☐ No
Comment:

Does the composition work?
☐ Yes ☐ No
Comment:

Is the image framed in an interesting way?
☐ Yes ☐ No
Comment:

Are there any obvious compositional flaws? (Example: A telephone pole sticking out of Aunt Edith's head.) ☐ Yes ☐ No
Comment:

What is the eye first drawn to in the photo? And is this in keeping with the narrative content of the photo?

Has exposure been used effectively and creatively to support the image?

Is there anything else you want to add to the evaluation?

"SIMPLICITY IS THE ULTIMATE SOPHISTICATION."
— Leonardo da Vinci

EMOTIONAL, INTUITIVE, AND NARRATIVE RESPONSE

Date: _____

For more about this exercise, please see *Achieving Your Potential* page 27.

IT'S BEEN RIGHTLY SAID that a photo with rich emotional content that is technically lousy will beat a technically perfect photo with banal content, any day of the week. This implies that the single most important aspect of evaluating a photo is determining the power of the inherently subjective, namely the extent to which the photo generates emotional, intuitive, and narrative response. Subjective or not, evaluating emotional resonance is crucial, and there are some criteria that can help you make this kind of evaluation—that's the point of this exercise.

"THE CHIEF ENEMY OF CREATIVITY IS 'GOOD SENSE'."
—PABLO PICASSO

Title of photo or sequence of photos:

❶ *What is the photo about?*

❷ *Does the photo tell a story? What is the story about?*

❸ *Is there a sense of mystery about the photo that makes you want to keep looking at it?*

❹ *Does the photo show you something you haven't seen before?*

❺ *Does the photo shed light on profound human relationships?*

❻ *Does the photo show something that isn't commonly seen?*

❼ *Does the photo show you something transformational, or that is being transformed?*

❽ *How unique or original is the photo?*

❾ *What feeling do you think the viewer gets from the photo?*

❿ *Is this feeling in harmony with the subject matter of the photograph?*

⓫ *Does the feeling of the photo mesh well with the formal aspects of the photo?*

⓬ *Is there anything else that needs to be taken into account when this photo is evaluated for emotional content?*

PRESENTATIONAL CONTEXT

Date: _____

For more about this exercise, please see *Achieving Your Potential* page 28.

"CLOTHES MAKE THE MAN," proclaimed Polonius in his sententious and pompous advice in William Shakespeare's *Hamlet*. Alas, as we grow older, we begin to realize that in the eyes of the world there is some truth to this. Sigh. A photograph, at least in part, is bound to be judged on its "clothing"—how the photograph is presented.

The good news is that presentation is comparatively straightforward and it's not that hard to determine a baseline. This is more a matter of craft than art, and generally knowledgeable viewers will usually reach consensus on matters of presentational context.

Title of photo or sequence of photos:

❶ *Are there dust, hair, or "gribblies" in the image?*

❷ *Are there any obvious flaws that should have been retouched?*

❸ *In a color image, does the color work?*

❹ *In a black and white image, is there a nice range from lights to darks?*

❺ *Does the image appear to have sufficient resolution?*

❻ *Are there areas of unattractive noise in the image?*

❼ *With physical prints, is the image nicely sized and placed on the paper?*

❽ *Does the subject matter work well (i.e., marry well) with the paper it is printed on?*

❾ *Do you see any other presentational issues?*

"WHEREVER THERE IS LIGHT, ONE CAN PHOTOGRAPH."
—ALFRED STIEGLITZ

YOUR FEELINGS ABOUT PHOTOGRAPHY

Date: _____

Why did you start taking photos? How long have you been a photographer?

What do you like most about photography and making photos?

What do you dislike about photography?

Who are your artistic and photographic heroes?

If you could have lunch with one great photographer or artist, living or dead, who would it be? If you could ask them one question, what would it be?

Is there anything else you want to add on how you feel about photography?

"THERE ARE NO RULES FOR GOOD PHOTOGRAPHS, THERE ARE ONLY GOOD PHOTOGRAPHS." —ANSEL ADAMS

TAKING A STAB AT YOUR BASELINE AND GOAL

Date:_____

What is the current state of your photography (baseline)? Please refer to Exercises 2–7.

What is your goal with your photography?

Don't think about this one too hard; just write down the first thing that comes to mind.

Harold sez: Your baseline will change over time, as will your goals. Don't hesitate to repeat the exercises related to goals and baselines as many times as you need to.

GETTING FROM HERE TO THERE

Date:_____

WRITE DOWN YOUR thoughts about the steps you need to take to get from where you are to where you want to be. Don't get fancy. Don't be shy. Just tell it as it is and keep it simple. Limit this to five steps. For the time being, don't pay too much attention to practicalities.

Enter your <u>baseline</u> from Exercise 9:

1)_____
2)_____
3)_____
4)_____
5)_____

Five intermediate steps to get to your goal

Enter your <u>goal</u> from Exercise 9:

YOUR FOCUS DETERMINES YOUR REALITY

PRACTICE, PRACTICE, PRACTICE!

Date: _____

For more about this exercise, please see
***Achieving Your Potential* pages 32 and 112.**

	Morning	Afternoon	Evening
Monday			
Tuesday			
Wednesday			
Thursday			
Friday			
Saturday			
Sunday			

Enter the amount of time you spend working on photography during the course of a week.

THE CRAFT OF PHOTOGRAPHY takes work. You want to get to the point where technical issues are second nature and internalized. The only way to do this is by practicing. Just as a good musician needs to spend many hours a day practicing, to become a photographic virtuoso, you gotta put in the time.

This exercise asks you to keep track of the amount of time you spend photographing in the course of your week.

"Try not. Do or do not. There is no try." — Yoda

Harold sez:
Compared to an art like painting, photography draws on a number of disparate creative skills, including the ability to work with a machine (a.k.a. your camera) and software.

Hey, Joe, how do you get to Carnegie Hall?

Practice, Practice, Practice!

AESTHETIC AND PRAGMATIC DOMAINS

Date:_____

For more about this exercise, please see *Achieving Your Potential* page 34.

SUCCESS AS A PHOTOGRAPHER cuts across two significant domains: the aesthetic and the pragmatic. The aesthetic involves visual and imaginative concerns. The pragmatic domain involves practical issues of craft and interaction with the real world. Exercises 12–15 help you explore your strengths and weaknesses across these two distinct domains, and how to integrate the steps needed for you to become stronger in both domains.

Where are you in terms of photographic aesthetics?

Where are you pragmatically?

Where would you like to be aesthetically?

Where would you like to be pragmatically?

Where are you on this grid? Where would you like to be?

"SOMEWHERE SOMETHING INCREDIBLE IS WAITING TO BE KNOWN." —JACK LONDON

AESTHETIC AND PRAGMATIC DOMAINS

PRACTICE, PRACTICE, PRACTICE

Aesthetic

This could be a great photographer just doing it for the love of it.

Someone who has mastered photography and the business of photography would be here.

Someone who is just getting started with photography and doesn't have an action plan would be here.

This could be someone who is working on becoming a better photographer and also has a plan for getting their work out there.

CREATING AN ACTION PLAN

Pragmatic

13

CREATING AN AESTHETIC ACTION PLAN

Date:_____

For more about this exercise, please see
Achieving Your Potential pages 34–52.

Enter the five necessary steps you need to get from where you are to where you would like to be in the <u>aesthetic</u> domain.

1)_____

2)_____

3)_____

4)_____

5)_____

14

CREATING A PRAGMATIC ACTION PLAN

Date:_____

For more about this exercise, please see
Achieving Your Potential pages 34–52.

Enter the five necessary steps you need to get from where you are to where you would like to be in the pragmatic domain.

1)_____

2)_____

3)_____

4)_____

5)_____

INTEGRATING THE AESTHETIC AND PRAGMATIC PLANS

Date:_____

For more about this exercise, please see
Achieving Your Potential **pages 34–52.**

TAKE YOUR AESTHETIC STEPS and your pragmatic steps and combine them to create an integrated plan that works on both aesthetic and pragmatic domains, with the most important three steps that you need to take.

Step 1:

Step 2:

Step 3:

Harold sez: Don't feel overwhelmed by the road ahead! Look back and give yourself kudos for how far you have come. Whatever you set your mind to <u>can be accomplished!</u>

AN IDEA THAT IS DEVELOPED AND PUT INTO ACTION IS MORE IMPORTANT THAN AN IDEA THAT EXISTS ONLY AS AN IDEA

UNLEASHING THE POWER OF YOUR PHOTOGRAPHIC IMAGINATION

Date: _____

For more about this exercise, please see *Achieving Your Potential* **pages 52 and 174.**

PHOTOGRAPHY SHOULD BE LIKE playing. For more about this, see Exercise 42, "Playing with Photography." And play itself works to release the creative imagination. Here are some ideas for photographic play that you can accomplish wherever you are and with whatever camera you have. Check each idea off the list after you have given it a go.

Remember: This exercise is about the process, not the result. So don't worry if the photos don't come out. You're bound to give your creative imagination a "slap upside the head" simply by trying.

IF YOU CAN DREAM IT, YOU CAN BUILD IT!

- ☐ Photograph something you've never photographed before.
- ☐ Photograph a naked person.
- ☐ Make a photo that shows time passing.
- ☐ Photograph a shadow.
- ☐ Make a photo while intentionally moving your camera.
- ☐ Photograph something **RED**.
- ☐ Go up to a stranger and ask them if you can photograph them.
- ☐ Photograph a flower.
- ☐ Create a photo without looking through the viewfinder or looking at the LCD.
- ☐ Put your camera on Bulb, and make a long exposure.

Harold sez: *Bulb* is a shutter speed setting that opens the shutter for as long as the shutter button is depressed. This allows you to make long exposures. Most cameras have the capability of making Bulb exposures. Check your camera manual to see if yours does and to find out how to use it.

VISUALIZING WITHOUT YOUR CAMERA

Date: _____

For more about this exercise, please see *Achieving Your Potential* page 58.

USING PIECES OF CARDBOARD and tape, create a photographic "frame." Then, use your frame to look at the world as you would through a camera, but without the ability to make any photos.

Draw a sketch in the box below of something that you've seen using the frame you made. Don't worry about your drawing skills; this is about jotting down ideas.

Draw what you "saw" without your camera:

Don't worry about your drawing skills; just do your best!

WHEN YOU REALIZE HOW PERFECT EVERYTHING IS, YOU WILL TILT YOUR HEAD BACK AND LAUGH AT THE SKY

LEARNING TO PRE-VISUALIZE

Date: _____

For more about this exercise, please see *Achieving Your Potential* page 60.

ONE OF THE MOST important skills that any photographer can have is learning how to accurately pre-visualize. This means having an image in mind before you click the shutter, knowing the steps you will need to take to realize the image, and successfully creating the image that you had in mind.

Start by finding an image that you would like to create. Frame it in your mind.

Describe the image you would like to create:

Steps for making the image:

How the image came out:

Try again! Repeat this process—it is so important to become a pre-visualization pro! You can do it!

Were you able to create the image that you pre-visualized?

☐ YES!

☐ NO!

Pat yourself on the back...you are great at pre-visualization.

IF WE COULD SEE THE MIRACLE OF A SINGLE FLOWER CLEARLY, OUR WHOLE LIFE WOULD CHANGE

Date:_____

For more about this exercise, please see *Achieving Your Potential* page 68.

IT'S REALLY HELPFUL TO be able to understand the story and kinds of stories that photographs tell. Sometimes the narrative gist and purpose of a photo is obvious. Other times, the story is not so clear. The purpose of this exercise is to help you understand photos based on the underlying narrative, even when the narrative isn't obvious.

Pick a photograph where you don't immediately see the story. This should be a photo that you didn't make, possibly by a well-known photographer.

Describe the photo you picked:

Where did you find it?

How does the photo make you feel?

Is the photo ☐ a story ☐ a poem ☐ other
Please explain your choice:

How does the content of the photo relate to your feelings?

How does the content of the photo relate to the narrative form (e.g., story, poem, etc.)?

DON'T MISS THE DONUT BY LOOKING THROUGH THE HOLE

Harold sez: I believe that all photographs are about a story. It's our job as creative photographers to find the stories we want to tell.

Repeat this exercise with many different kinds of photos until you feel confident in your ability to suss out the underlying narrative. Practice makes perfect—once again!

BRINGING THE STORY INTO YOUR OWN PHOTO

Date: _____

For more about this exercise, please see *Achieving Your Potential* page 68.

NOW THAT YOU HAVE experience with detecting underlying narrative in imagery that is not your own (see Exercise 19), it is time to bring this into your own work. Go forth and create a photo with narrative of some kind intentionally in mind. Create a very rough overview sketch of the image below once you have made it, and then answer the questions.

Draw your rough sketch here:

> Repeat this exercise as many times as you need to until you feel you have control of narrative in your photos.

Describe the photo you created:

What was your intended narrative?

How does the photo make you feel when you look at it?

Is the photo ☐ a story ☐ a poem ☐ other
Please explain your choice:

How does the content of the photo relate to your feelings?

How does the content of the photo relate to the narrative form (e.g., story, poem, etc.)?

Do you think the narrative works as intended? If not, what is the revised narrative?

"THE ONLY ZEN YOU CAN FIND ON THE TOPS OF MOUNTAINS IS THE ZEN YOU BRING UP THERE." —ROBERT PIRSIG

Date:_____

For more about this exercise, please see *Achieving Your Potential* page 68.

THE IDEA BEHIND THIS exercise is to bring narrative in photography out of the closet of the single image, and into the broader space of the photographic sequence. As such, a photographic sequence is typically used in a story that is essentially journalistic in nature. In the long run, you may or may not wish to practice journalism, but in the short run, understanding narrative sequence in the context of a photographic story can only help you with mastering photographic storytelling.

The goal of this exercise is to plan, storyboard, and create a sequence of six images that tell a story.

Write the overall concept for your story here:

Explain the role that each of the six images in your story sequence will play:

❶ _____ ❷ _____

❸ _____ ❹ _____

❺ _____ ❻ _____

Grab a piece of paper and sketch the six images in their narrative order. You are making a storyboard. Staple it in here, so it becomes a part of your workbook.

Next, create each of the photographs in your story-board. Show the completed photos to a friend who does not know the story you are trying to tell. Do they understand your story?

Harold sez: With a single image, the narrative is often hidden, but with a sequence of images that make up a story, the narrative is usually pretty clear. Practicing narrative with a sequence will help you embed narrative into a single image.

"You can see a lot just by looking."
—Yogi Berra

FINDING THE LEDE IN SOMEONE ELSE'S IMAGE

Date: _____

For more about this exercise, please see *Achieving Your Potential* page 70.

THE "LEDE" IS NEWSPAPER jargon for the most important part of the story. Creating great images means knowing what's important in your photo and using the photo to emphasize the important element. In other words, as they say in the newspapers, "don't bury the lede."

Exercises 22–24 are intended to help you find the key subject matter in your images. Pick a photograph where you don't immediately see the lede. This should be an interesting photo that you didn't make.

Describe the photo you picked:

Where did you find it?

What is the point of the image?

What matters most about the image?

After answering these questions, do you understand the lede of the photo? What is it? If you don't know, make a guess:

Repeat this exercise with many different kinds of photos until you feel confident in your ability to determine the lede.

If you had to guess about the lede, show the image to a few friends and ask them what it is about. Try to come up with a consensus.

"THE OBSCURE WE SEE EVENTUALLY. THE COMPLETELY OBVIOUS, IT SEEMS, TAKES LONGER." —EDWARD R. MURROW

FINDING THE LEDE IN YOUR PHOTO

Date: _____

For more about this exercise, please see *Achieving Your Potential* page 70.

NOW THAT YOU HAVE experience with finding the lede in imagery that is not your own (see Exercise 22), it is time to bring this to your own photographs. Go out and create a photo with the lede in mind.

Create a very rough sketch below of the image you want to make with the lede emphasized, and then make the image and answer the questions.

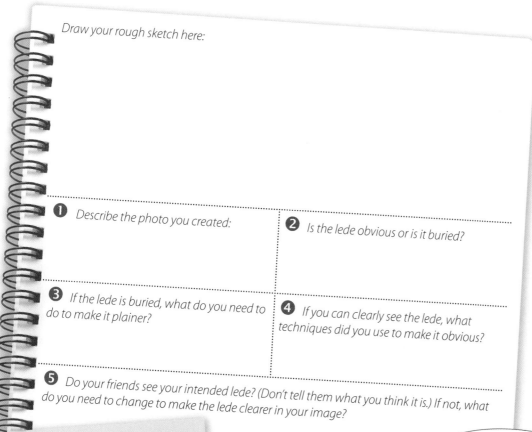

Draw your rough sketch here:

❶ Describe the photo you created:

❷ Is the lede obvious or is it buried?

❸ If the lede is buried, what do you need to do to make it plainer?

❹ If you can clearly see the lede, what techniques did you use to make it obvious?

❺ Do your friends see your intended lede? (Don't tell them what you think it is.) If not, what do you need to change to make the lede clearer in your image?

Revise your image and show it to your friends again. Repeat this process until they can clearly recognize the lede.

Get your friends some coffee!

Harold sez:
Repeat this exercise as many times as you need until you feel that you have control of the narrative issues in your photos.

"SOMETIMES IT'S NECESSARY TO GO A LONG DISTANCE OUT OF THE WAY IN ORDER TO COME BACK A SHORT DISTANCE CORRECTLY." — EDWARD ALBEE

PHOTOGRAPHY AS A QUEST

Date:_____

For more about this exercise, please see *Achieving Your Potential* page 79.

I BELIEVE THAT ONE of the best ways to approach photography is as a quest, in the sense that knights-errant of old accepted quests and adventures. These knights went out to do something gallant and brave with the understanding that there would be peril as well as opportunity and repetition as well as adventure. The resolution of a quest is never what it seems when the quest is undertaken, and the adventurer must be prepared to explore side paths. Remember, the quest is about the journey, not about the destination.

Imagine that you can do anything you want. What is your ideal path as a creative photographer?

To achieve your goals along your ideal path, what areas of photographic technique do you need to reinforce, brush up on, and practice?

Good photographers need to learn to see beyond superficial appearances. Give a few examples of things that you have seen that are different than the way they appear on the surface:

Undertake a photographic project with the clear idea that you will look for interventions that change the direction of the project as you go along. Think of it as planned serendipity. Write down the project you've undertaken when you first begin this "quest":

Now describe how your project has changed because of changing circumstances and direction:

Harold sez: Often detours create better images than "sticking to the plan," but it is still important to have a plan.

CHANGING PROBLEMS INTO POSSIBILITIES

Date:_____

For more about this exercise, please see *Achieving Your Potential* page 82.

THE POINT OF THIS exercise is to develop your creative "muscles" to use things that go wrong to your benefit. This is the proverbial "making lemonade from lemons."

1) Think back on a photograph or photographic shoot that went wrong and where the photos came out badly. Describe it:

2) With the benefit of hindsight, what could you have done to turn the situation around? Is there a way you could have used the problems to benefit the end results?

Problems often come up in photography. No doubt you'll have a chance to flex your new "problem redirection muscles" soon. The next time things start to go "south" when you are photographing, see if your insights from this exercise help you salvage the situation.

FINDING NEW WORLDS

Date:_____

For more about this exercise, please see *Achieving Your Potential* page 84.

SOME OF THE MOST creative photographs find "worlds" that are the ordinary viewed in extraordinary ways. Here are some ideas to help you bridge the gap into "different worlds."

Try some extreme close-up photography of something like a leaf.

Photograph after dusk or during the night.

Photograph refractions through a glass of water.

Photograph into a mirror.

What cool ideas do you have?

27

OVERCOMING RESISTANCE: WHAT STOPS YOU FROM TAKING PHOTOS?

Date: _____

For more about this exercise, please see *Achieving Your Potential* page 87.

ONE OF THE MOST difficult aspects of resistance to creative photography is the voice in each of our heads that appears to give very rational reasons why we shouldn't even attempt to make a photo. For example, "I'm too busy to stop to do photography," or "I'm just too tired."

This voice, which I sometimes like to call "the Whiner," is disarmed when you call attention to it. By bringing the Whiner out of the shadows and into the bright light of day, you will be able to see just how pathetic and fearful the Whiner is and become able to overcome this nattering nay-saying nabob of negativism.

List things that stop you from photography and from making specific photographs. Start with the general and continue on down to the specific.

General resistance

1. Ex: *I'm just not good enough.*
2. _____
3. _____
4. _____

Specific resistance

5. Ex: *The photo is on the other side of the road. I'll have to make a U-turn.*
6. _____
7. _____
8. _____

When you have completed your list, it's time to banish the things that stop you from photography by having a "banishing ceremony." There are several different forms this can take, but usually one approach is to write down the things that stop you as a list, like the one above. Now, burn the list, or tear it to pieces and toss it in the air, or bury it in your yard with all due ceremony.

Keep in mind that you have banished the things that stop you from photographing. The next time you have a photographic idea, however fleeting, and resistance rears its ugly head, say "I have banished you—be gone!" and make a point of following through on your idea.

Achieving Your Potential As a Photographer: Companion Workbook

"KEEP AWAY FROM PEOPLE WHO TRY TO BELITTLE YOUR AMBITIONS. SMALL PEOPLE ALWAYS DO THAT, BUT THE REALLY GREAT ONES MAKE YOU FEEL THAT YOU, TOO, CAN BECOME GREAT." –MARK TWAIN

Date: _____

For more about this exercise, please see *Achieving Your Potential* **page 90.**

TIME IS PROBABLY THE most powerful element that you can control in photography to reveal the unseen, because your choice of shutter speed determines how motion is rendered over time. The point of this exercise is to create images that capture motion on a spectrum from instantaneous to almost endless.

Take a look at Exercise 35 to learn more about controlling shutter speed and time with your camera.

1. Choose a subject matter that's in fairly high speed motion, such as a waterfall or cars on a highway. Use a fast shutter speed (1/1000 of a second or faster), to freeze the motion.

2. With the same subject, use an intermediate shutter speed (1/8 of a second to 1/60 of a second) to partially freeze the motion of your subject and also show some blurring.

3. With the same subject one last time, use a slow shutter speed (depending on the light from 1 to 5 seconds) to render the motion as blurred and abstract.

4. In comparatively low light, choose a subject in motion, such as waves or clouds, and use a long shutter speed (15 seconds to 2 minutes) to create motion blurs that are attractive and abstract.

5. With your camera on a tripod, go out at night and capture the motion of the Earth relative to the stars. You'll need an aggregate exposure of 20 minutes and longer to really start seeing star motion.

"A HUNCH IS CREATIVITY TRYING TO TELL YOU SOMETHING."
—FRANK CAPRA

Here are some ideas for photographic subject matter that creates interesting results when photographed with different shutter speeds:

A waterfall in motion or other moving water

Cars in motion

Waves

People in a crowded public space

Stars at night

Harold sez: The best way to capture the motion of star trails is to use a composition technique called "stacking." This combines multiple, shorter exposures to create a single aggregate photo with a longer effective exposure length.

29

EXERCISING THE HISTORICAL IMAGINATION

Date: _____

For more about this exercise, please see *Achieving Your Potential* page 99.

IMAGINATION IS A MUSCLE and the more muscles are exercised, the stronger they get. One important kind of imagination is historical imagination. What did something look like in the historical past? What was happening in that place at that time in the past? What were people like?

This exercise has two parts, pre-visualizing the historical past and then re-creating it.

First, locate a place with an interesting past and describe it:

Next, pick a time frame and try to understand what it might have looked like. Bear in mind that there's a great deal of variety in what the past could have been like. The further back, the more different it will be; however, if there has been recent disturbance of the time line—a new development has supplanted a traditional village, for example—then there can be a radical difference even though only a short time has passed.

How many years ago are you trying to imagine? Describe the scene as it would have been at the time period you are imagining:

How does your imagination differ from what the scene looks like now?

Write down the steps you need to take to re-create the scene that you are imagining:

Now that you've done the grunt work, go out with your time machine camera, and create an image that captures the scene from the past as you've imagined it. Check this box when you are finished:

"IT IS THE POWER OF THE MIND TO BE UNCONQUERABLE."
—SENECA

Date: _____

For more about this exercise, please see *Achieving Your Potential* **pages 108 and 164.**

MANY TIMES THINGS THAT are really relatively petty get in the way of our photography. Maybe this form of resistance doesn't actually stop us from taking pictures, but it sure as heck makes the process of photography less fun, and limits your ability to be truly creative.

The idea behind this exercise is to become clear about the things that annoy and irritate you. With clarity, you may be able to overcome some of these factors or alternatively to find work-arounds so they are no longer bugging you, sapping your creativity, and being parasites on your power.

To complete this exercise, list the petty annoyances.

1. *Ex: There's too much noise for me to focus!* _____

2. _____

3. _____

4. _____

5. _____

6. _____

7. _____

8. _____

For each petty annoyance, come up with a plan for dealing with it. Either solve the problem, for example by complaining about the noise and making it stop, or decide that you can really live with it in the grand scheme of things. In either case, once you have a plan for dealing with the annoyance, cross it off the list above.

"IT ISN'T THE MOUNTAIN AHEAD TO CLIMB THAT WEARS YOU OUT, IT'S THE PEBBLE IN YOUR SHOE." —MUHAMMAD ALI

INTERIM PROGRESS REPORT

Date: _____

Harold sez:
Great job! Keep up
the good work!

"NEVER DISCOURAGE ANYONE WHO CONTINUALLY MAKES PROGRESS, NO MATTER HOW SLOW." —ARISTOTLE

Think back to where you were when you completed the first exercise in this workbook. Compare that to where you are now:

How have your goals changed?

How has your baseline changed?

How have you changed?

USING PATTERNS

Date:_____

For more about this exercise, please see *Achieving Your Potential* page 118.

THE ABILITY TO RECOGNIZE and use patterns effectively is crucial to many kinds of photography. This exercise gives you a number of tools and techniques for enhancing your use of patterns.

Here are some sample basic patterns:

Pick one of these patterns and create a photo that uses objects in nature or things you construct. Then do it again with another pattern.

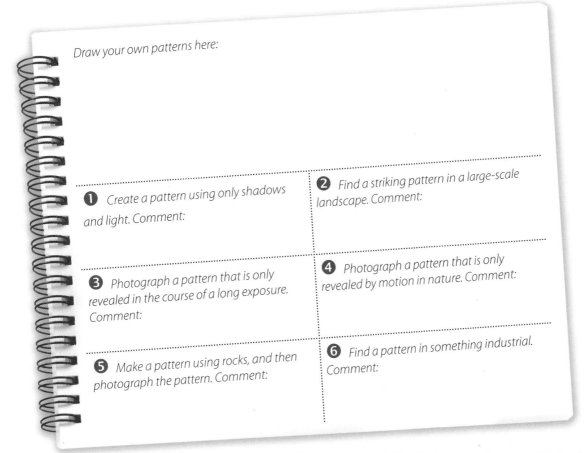

Draw your own patterns here:

❶ Create a pattern using only shadows and light. Comment:

❷ Find a striking pattern in a large-scale landscape. Comment:

❸ Photograph a pattern that is only revealed in the course of a long exposure. Comment:

❹ Photograph a pattern that is only revealed by motion in nature. Comment:

❺ Make a pattern using rocks, and then photograph the pattern. Comment:

❻ Find a pattern in something industrial. Comment:

"THE TRUTH IS OUTSIDE OF ALL FIXED PATTERNS."
—BRUCE LEE

33 LENSES AND FOCAL LENGTHS

Date: _____

For more about this exercise, please see *Achieving Your Potential* **page 124.**

LENSES ARE A PHOTOGRAPHER'S paint brush. What you can do with a photo depends upon your choice of lens. It's *really* important to get to know your lenses in as much intimate detail as possible. This exercise will help you become totally familiar with your lenses.

Indicate special features about your lenses, such as macro capability

"THE REAL QUESTION IS NOT WHAT YOU LOOK AT BUT WHAT YOU SEE." —HENRY DAVID THOREAU

Step 1: List the lenses in your kit in order, as much as possible, by focal length:

Prime (fixed focal-length lenses)	Zoom (variable focal-length lenses)

Step 2: Choose one wide-angle, one normal, and one telephoto focal length and list them here:

Wide-angle lens:

Normal lens:

Telephoto lens:

Step 3a: With the focal lengths you have selected, photograph the same subject.
Step 3b: Try this from a single, stationary position.
Step 3c: Try this while moving around.
Step 4: Now, try the same thing with a different kind of subject matter.

What is your experience of using these different focal lengths? Which focal length works best for which kind of subject? Which focal length do you prefer and why?

When you write down your lens, also include the maximum aperture that it is capable of, for instance, 55mm f/1.4 (the f/1.4 is the maximum aperture of this lens).

Date: _____

For more about this exercise, please see *Achieving Your Potential* page 128.

THE RULE OF THIRDS proposes a hypothetical formal compositional rule: Draw vertical and horizontal lines in pairs across your composition with the lines evenly spaced so they divide the composition into nine even rectangles. The important parts of the composition should fall according to the Rule of Thirds where the lines intersect.

According to the Rule of Thirds, the circled areas are the important parts of the composition

"LEARN THE RULES LIKE A PRO, SO YOU CAN BREAK THEM LIKE AN ARTIST." —PABLO PICASSO

Step 1: Make a "Rule of Third-ifier." You will need eight strips of cardboard and some tape. Tape four of the strips together in a photo-shaped rectangle. Next, take the remaining four strips and carefully lay them over the rectangle to form the sectional divisions for your Rule of Third-ifier.

Step 2: Try your Rule of Third-ifier on a variety of subjects.

> Where does the composition seem to work well using the Rule of Thirds? And where doesn't it work so well?

Step 3: Make some photos that use the Rule of Thirds to enhance the composition.

Step 4: Try to make some photos where the Rule of Thirds does not apply and/or where applying the Rule of Thirds actually makes the composition worse.

> What are your feelings about the Rule of Thirds after completing this exercise?

Harold sez: There are NO rules in art! When someone proclaims a rule, such as The Rule of Thirds, be skeptical, *very* skeptical.

MASTERING SHUTTER SPEED

Date: _____

For more about this exercise, please see *Achieving Your Potential* page 130.

"CREATIVITY TAKES COURAGE." – HENRI MATISSE

ONE OF THE KEY creative controls on your camera is the shutter speed dial. Shutter speed is not actually a speed, but rather it's the duration of time that the shutter is open, letting the light in to hit your sensor. To achieve your potential as a photographer, you need to know the many possibilities available in the shutter speed control.

Camera motion	Subject is still	Subject is moving
Camera is still (on a tripod)	Motion is frozen	Motion is blurred (unless an extremely fast shutter speed is used)
Camera is moving	Motion is blurred	Motion is very blurred

Take a look at the chart above showing how motion is rendered depending upon both the camera and the subject. The object of this exercise is to observe this for yourself, and to begin to understand which shutter speeds work best with the different combinations. To do this exercise, you will probably need to use Manual Exposure mode. Please take a look at your camera manual to learn how to do this.

Harold sez: To learn to work better with shutter speed, also take a look at Exercise 28, which emphasizes time. Time is closely related to shutter speed, while this exercise is primarily about controlling your camera. If you work with both exercises, you should get a good handle on both shutter speed and time.

Step 1: In a bright-light situation, photograph all the possibilities shown in the chart above. Make your own chart below, filling in the white areas, showing the shutter speeds you used, and subjectively describe how the three kinds of blur differ.

Camera motion	Subject is still	Subject is moving
Camera is still (on a tripod)		
Camera is moving		

Step 2: In a low-light situation, use the chart at the top of this page to photograph all the possibilities. Fill in the white parts of the chart below with your results:

Camera motion	Subject is still	Subject is moving
Camera is still (on a tripod)		
Camera is moving		

FINDING YOUR PERSONAL PASSION

Date: _____

For more about this exercise, please see *Achieving Your Potential* page 139.

PHOTOGRAPHERS WHO ARE GOOD at their art generally understand that their photos are examples of how they see. How you see is an extraordinarily important part of who you are. The best and most passionate photographs come from passionate people photographing subject matter that they are passionate about. To make more emotionally resonant photos, first find out what you are passionate about and what drives you.

List some things that you really care about (are passionate about):

1. _____

2. _____

3. _____

4. _____

For each item in your list, how can you make this into an image?

1. _____

2. _____

3. _____

4. _____

Now go out and make your passionate photographs!

"ACTION IS THE FUNDAMENTAL KEY TO ALL SUCCESS."
—PABLO PICASSO

37 APERTURE AND BOKEH: PLAYING WITH YOUR LENSES

Date: _____

For more about this exercise, please see *Achieving Your Potential* page 143.

ALONG WITH SHUTTER SPEED (see Exercise 35), aperture is one of the most important creative controls your camera has. When it comes to the aperture setting of your camera, there are three things that are important creative aspects of your photos that aperture controls:

1. The amount of light let in

2. The depth-of-field = the range of depth that is in focus

3. Bokeh = the attractiveness of background out-of-focus areas

> Besides aperture, depth-of-field and bokeh are dependent on the focal length and the design of a specific lens

Step 1: List the lenses in your kit with their maximum and minimum apertures (grab another piece of paper if you need to).

Lens	Maximum aperture (wide open)	Minimum aperture (stopped down)

Harold sez:
Remember, the background of a photo is as important to the success of a composition as the foreground. Your choice of aperture will help decide how a background is rendered.

Step 2: For each lens in your list above, take a photo with each of the possibilities in the table below. The idea is to create photos that are properly focused and also where you have intentionally thrown the lens way out of focus. With both in-focus and out-of-focus possibilities, see what your photos look like at wide-open, intermediate, and stopped-down apertures. For each lens, when you make your photo, put a check in the chart below at each of the possibilities.

Lens: _____

Aperture

	Wide open	Intermediate	Stopped down
In focus			
Out-of-focus			

For each lens that you have tested, what are the visual differences depending on the settings when the lens is in focus and out of focus, and the aperture is set to wide open, intermediate, or stopped down? Describe:

Photocopy this chart, so you have one for each lens that you listed

Date: _____

For more about this exercise, please see
Achieving Your Potential **pages 45 and 146.**

WHAT GETS YOU INTO the zone? Think about it for a second. Plan a photo-shoot indoors or in the field that maximizes these things so you can get into the zone. The check list below will help you prepare to enter the zone.

Before the photo-shoot

- ☐ A few days before your project, eat really healthily.
- ☐ For a few days before your project, make sure you get plenty of sleep.
- ☐ Research what you will be photographing.
- ☐ Be sure you understand your camera, lens, and gear, and have your camera manual handy.

Make a plan for your photo-shoot:

During the photo-shoot

- ☐ During the photo-shoot practice from time to time disassociating (see Exercise 4).
- ☐ Put petty annoyances out of your mind (see Exercise 30).
- ☐ Indoors, play music that is soothing and upbeat. If you are out in nature, be sure to listen to the sounds around you.
- ☐ Focus. The only thing on your mind should be the photo-shoot.
- ☐ Turn off your phone ringer and put your phone on Do Not Disturb.
- ☐ Every now and then, take a moment to stretch, unkink your body, and breathe. This will help keep your mind creative.

"Do not dwell in the past, do not dream of the future, concentrate the mind on the present moment." —Buddha

MAKING A SELF-PORTRAIT

Date: _____

For more about this exercise, please see *Achieving Your Potential* page 156.

MAKING A SELF-PORTRAIT can be great fun! It is also a good photographic exercise. Whether or not the end result is "art," by setting out to make a formal self-portrait, you will certainly learn how to make more interesting selfies to post online.

"WHAT I CONSIDER THE HUMAN PREDICAMENT MAY SIMPLY BE MY OWN." –RICHARD AVEDON

Step 1: Make a self-inventory. Write down the characteristics that are most important about you:

Step 2: Explain how you plan to use a photo to show your most important characteristics:

Step 3: Use your plan to make your self-portrait.

Step 4: Show your self-portrait to some friends. Do they think it represents you well?

Step 5: Give the friend a blank piece of paper. Ask them to show your self-portrait to someone who doesn't know you. The friend should be neutral and non-communicative about you and your portrait. The friend should ask the stranger to describe what they think you are like based on your self-portrait. Get the friend to write down the description verbatim. Transcribe what the stranger said here:

Step 6: How does the anonymous description compare to your self-inventory? What did the stranger get right, and what did they get wrong? What can you do in a future self-portrait to better convey your important characteristics? Write your thoughts here; then make a new self-portrait.

Date: _____

For more about this exercise, please see _Achieving Your Potential_ page 163.

IN MUSIC AND ENGINEERING, to modulate something means to restrict its range. For example, in sound engineering, amplitude modulation restricts the highs and lows in sound waves. Radio signals are treated with amplitude modulation; otherwise, when you turn on a car radio, you would be alternately blasted and not able to hear the sound.

Some people shoot literally thousands of photos when one would be better. The concept of modulation in photography means in part to make an appropriate amount of photos. Here are some ideas that may help you modulate the volume of your photography.

- Take your camera off Burst Mode. It sounds like a machine gun and is disruptive and destroys any possibility of being in the zone (see Exercise 38).

- Spend a day shooting different scenes, but allow yourself only one shot of each scene.

- Spend a week where you only take one photo each day—make each one count!

For this exercise, choose a place or subject that is easy to return to over the course of a week. Plan several photo-shoots. Each time you go, alternate between these two thoughts: "I am going pig out and take, literally, tons of photos," and "I am going to take only one photo for this session of something that is really special." Here's a table so you can mark what you did each time.

	Today I am going to take tons of photos. Enter the number you took:	Today I am going to take only one photo. Check off the day:	After you are finished with your week, think about several things: How did you feel after a shoot where you took many photos as opposed to only one photo? Were you calm or jittery, more or less satisfied?
Monday			
Tuesday			
Wednesday			
Thursday			
Friday			
Saturday			
Sunday			

"Everything in moderation, even moderation."
—Oscar Wilde

CREATIVE DESTRUCTION

Date: _____

For more about this exercise, please see *Achieving Your Potential* page 171.

THE IDEA BEHIND CREATIVE destruction is to intentionally introduce random and anarchic elements with the full understanding that these elements may ruin your photo. So relax! There is also the possibility that creative destruction may salvage a mediocre image and add a powerful and unexpected thrust of serendipity.

Here's a list of some possible ways that you might introduce an element of creative destruction into your photograph:

- Create an image by shining a harsh light at your camera.
- Photograph something behind you without looking at the subject.
- Intentionally way over-expose or under-expose an image.
- Gently toss your camera in the air and catch it while the shutter is open.

Can you think of some ways to add creative destruction to your photos? As you think about specific methods of creative destruction, you may find it hard to come up with specifics. This is because creative destruction is so far removed from the normal way we think about the process of photography. So, relax, forget about an orderly and logical life, and think about some weirdness you can come up with.

Write down some of your creative destruction ideas here:

Using some of the creative destruction ideas on this page, go forth and make some photos. Did any of the photos come out? Did your use of creative destruction lead you to come up with some interesting ideas? Will you be using creative destruction in your photography in the future?

"THE URGE TO DESTROY IS ALSO A CREATIVE URGE." —PABLO PICASSO

Harold sez:
Remember, it is important to take risks, make mistakes, and get out of your comfort zone!

Date: _____

For more about this exercise, please see _Achieving Your Potential_ page 177.

PLAY IS IMPORTANT IN all aspects of life. Too often, we lose our sense of play, and are taught and trained to only regard the straight and narrow. Kids know how to play. Why is it then that so few adults seem to enjoy playing?

Playing is fun, and most folks think photography is fun, too. If you lose your sense of play around photography and begin taking it too seriously, then you will enjoy photography less. Somewhat surprisingly, you won't be as good a photographer, either. Time and again, studies have shown that integrating play into your life, work, and activities enriches everything you do.

❶ It's time to do some warm-up play. Take 5 to 10 minutes and jump, skip, climb something, and run around the block. Perhaps you could even get to a kids' playground and slide down the slide and climb on the jungle gym!

❷ Kids never worry about what they look like when they are playing, but adults stop themselves because they think they are going to look silly. Intentionally do something really silly or funny by wearing a silly hat, costume, or make-up.

❸ When is the last time you really had fun photographing? What did you photograph? What made it fun?

❹ Photograph several things in one photo that don't normally go together and that look ridiculous together. For example, a tennis shoe next to an elegant plate of food.

❺ Play with scale by photographing something small to make it look big, and something big to make it look small.

❻ Photograph people clowning around together.

❼ Photograph toy animals, such as stuffies or a rubber ducky.

❽ Hand your camera to a stranger and ask them to take a photo.

What ideas do you have about how to play with your camera? Jot them down here:

For more ideas about playing, see Exercise 16.

Bring the joy back into your photography!

Get over the fear of being ridiculous for once and for all! Most truly creative people are ridiculous at times!

"IT'S A HAPPY TALENT TO KNOW HOW TO PLAY." —RALPH WALDO EMERSON

For more about this exercise, please see
Achieving Your Potential **pages 182–184.**

A GREAT WAY TO think of your progress in life and as a photographer is what Joseph Campbell called "the Hero's Journey." In this archetype, of course, you are the hero as photographer—so it's not just any hero who is journeying. No heroic journey is ever possible without pitfalls, pratfalls, and speed bumps. So the process of *Your Photographer's Journey* can be conceptualized as understanding where you are (the baseline), overcoming obstacles to improvement (using the exercises in this workbook), and establishing a new baseline. It certainly is worth pointing out that every hero's journey bears some similarity to the archetypical hero's journey—but will have features that are uniquely yours. **Tell the story of your "journey"!**

"THE PRIVILEGE OF A LIFETIME IS BEING WHO YOU ARE." —JOSEPH CAMPBELL

Evaluation (baseline):

Tell the story of how you overcame the obstacles and how you have improved.

Overcome obstacles (improvement):

Tools for evaluation and determining baseline:

- Exercise 2, *Road Map to Success*
- Exercise 3, *The Steps to Evaluating Your Own Work*
- Exercise 4, *Disassociating*
- Exercise 5, *Formal Photographic Evaluation*
- Exercise 6, *Emotional, Intuitive, and Narrative Response*
- Exercise 7, *Presentational Context*
- Exercise 9, *Taking a Stab at Your Baseline and Goal*
- Exercise 10, *Getting from Here to There*

Harold sez: All great journeys begin with the first step. No journey is truly worth undertaking unless it takes you out of your comfort zone.

Some tools for overcoming obstacles and photographic improvement:

- Exercise 11, *Practice, Practice, Practice!*
- Exercise 13, *Creating an Aesthetic Action Plan*
- Exercise 16, *Unleashing the Power of Your Photographic Imagination*
- Exercise 18, *Learning to Pre-visualize*
- Exercise 23, *Finding the Lede in Your Photo*
- Exercise 25, *Changing Problems into Possibilities*

Evaluate again (set new baseline):

Overcome obstacles to your new baseline (improvement):

FROM HERE TO THERE

Each step is one step closer to your final goal.

| Where you are now | → | **STEP 1** Road Map to Success (Page 16) |

Do it again! STEP 2 Road Map to Success

Do it again! STEP 3 Road Map to Success

RESET TO NEW GOAL

RESET TO NEW GOAL

YOUR FINAL GOAL!

RESET YOUR GOAL AS MANY TIMES AS YOU NEED TO UNTIL YOU REACH...

Your Journey continues; keep on evaluating new baselines and overcoming the obstacles!

CREATING A PORTFOLIO OF YOUR WORK

Date: _____

For more about this exercise, please see *Achieving Your Potential* page 192.

MAKING A PORTFOLIO OF your work is a very important way to support creativity and achievement in photography. The experience of editing images and presenting them gives you valuable skills in pre-visualizing and understanding what matters in photographic image making. In addition, by creating your own portfolio, you are drawing a symbolic line in the sand. This line says "I am good enough to have a portfolio," and "Here is a portfolio that represents me." In other words, it is a cry to the world that you take yourself seriously as an artist. There are many kinds of portfolios and many ways you may decide to present your work. This checklist will help you track your progress.

❶ What is your portfolio about?

❷ Name your portfolio:

❸ How many images will be in your portfolio?

❹ Have you edited your work to choose the images in your portfolio?

❺ Have you posted your portfolio as an online gallery or album? What is the web address?

❻ Will you use an online service to print a publication on demand (POD) book? If yes, which service? ☐ Yes ☐ No

❼ Will you make a print portfolio in addition to your online portfolio? ☐ Yes ☐ No

Print portfolio checklist

☐ Prepare photos for printing.

☐ Decide on the physical form of the portfolio.

☐ Design and order the contents of the portfolio; choose a container, box, or binding.

☐ Print the portfolio.

"WE HAVE TO CONTINUALLY BE JUMPING OFF CLIFFS AND DEVELOPING OUR WINGS ON THE WAY DOWN." –KURT VONNEGUT